MONICA DENGO

LEAVE YOUR MARK

THE PLEASURE OF WRITING BY HAND

niggli

TABLE OF CONTENTS

the
creative
potential
of wood
by hand

PREFACE

Leave Your Mark is the perfect handbook for people who think they have poor handwriting, for people who never or rarely write, for people who have no idea that writing can be fun and *creative*.

These pages will help us form a new opinion about handwriting. We'll venture into new territories. We'll explore shapes and forms, spaces, balances. And we need no specific training to do so. In fact, readers who know nothing of this activity and its conventions will have even more fun, as everything will be new and stimulating to them.

We'll try to understand the rules of legibility, learning the forms and rhythms of handwriting. We'll see which norms can be set aside so as to retrieve the expressive sphere, including the exploration of illegible handwriting.

First of all, though, we'll tackle the most frequent doubts and questions together. If you're in a hurry to start writing, you can skip the following pages and come back to them later.

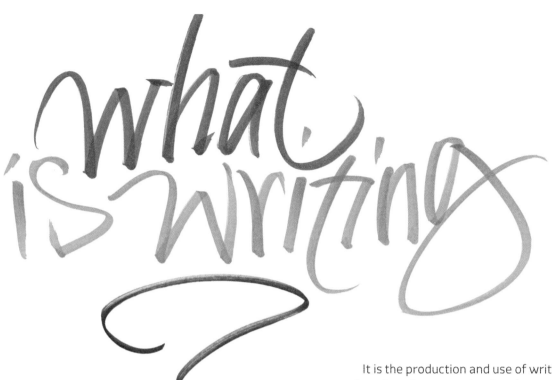

what is writing?

It is the production and use of writing systems with the aim of communication (among other things)[1]. There are several types of writing systems. We'll be working on a specific one: the Latin alphabet.

To put it very simply, we can say that our alphabet appears to be a writing system wherein graphic marks represent the sounds of the language. Over time, the development of these basic signs and the structure of the text has been guided by a primary requirement: legibility. Legibility depends on several factors: the limited number of signs that make up an alphabet; the immediacy of identification; the order and structure with which they appear on the page to help the eye move from one sign, one word, one line to another...

Handwriting can be much more than the graphic transcription of a language. And even if its use has by now dwindled drastically, the *potential* of its expressive and personal aspect remains intact. And this is precisely what we will try to bring out, once we've mastered the basics.

[1] Giorgio Raimondo Cardona, *Antropologia della scrittura*, Turin 1981, p. 22.

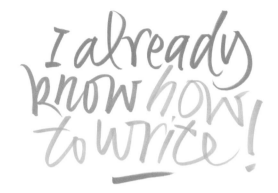

Here you'll meet a new writing style, the italic script. Practice will help you learn its shapes and rules. If you're already familiar with them, you can get straight to the point: have fun ignoring the rules and filling the pages as you discover all you can do with handwriting.

It's not just a useful skill. Writing by hand means going back to the root of our need to express ourselves, blending sign, word, body into a whole. Practice is the only way to understand its importance.

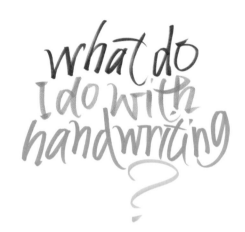

Because it influenced all the cursive writings that came after it. Furthermore, its history proves the model is flexible and easy to personalise.

The beauty of handwriting lies in the space it leaves for mistakes — and mistakes are a useful way to learn. Above all, they offer the chance to find creative solutions.

many letters many hands

Italic script can be written in several ways. Letters are flexible in their shapes, and like rubber bands we can transform them. For example, the letter "a" can be broadened, narrowed, and slanted in any way you wish. We can do the same with the capital letters. The result? Everyone can find their own way of writing.

writing instruments

To practice on the handbook, you can use any kind of pencil, pen and marker. If you're working on wider surfaces, you can also use chalk, paintbrushes, crayons, charcoal crayons, etc. No matter what instrument you use, its tip makes the difference. With a fine-tip marker, you can write tiny letters; a thicker point results in larger-size letters. If you're intrigued by these variations in stroke, my advice is to try writing on drawing paper with a little ink and lots of different instruments – even invented ones.

writing with a brush point pen

ami

ami

ami

For this handbook, I mainly used brush point pen, because this kind of tip best captures the movement of the writer's body. Experimenting with the pressure you apply on the ascending and descending strokes of a letter will help you establish your own gesture. More on this in the third and fourth sections of *Leave Your Mark*.

the ductus

This Latin word, in palaeography, refers to how a type of writing is marked out: ductus is said to be cursive when the letters are looped together, and ductus is said to be disjointed when the letters are written separately.

Thus, by ductus we mean the gesture we make as we write, moving our pen on the paper and in the air. It consists in the number, sequence, and direction of the strokes used to form a letter or a word in a certain style of writing. It's essential in cursive, because it allows us to join letters together following a path that is both logical and functional. In other words, the ductus.

In any case, the best way to familiarise with ductus is to play around, as I suggest in the following pages.

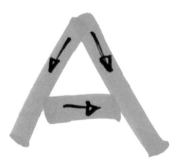

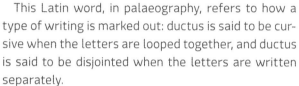

The word *rhythm* is used in several spheres and with different shades of meaning. It denotes the regular repetition of certain events (shapes, sounds, beats, etc.) and the frequency with which they follow one another.

We'll be using it often in this handbook because rhythm plays an important role in writing. For now, suffice it to say that rhythm is the repetition of the gesture and its result on the page. It entails an experience that develops over at least two levels —physical and visual.

In Italic script, the counters (the enclosed area in a letterform) are neither round nor oval. In his pamphlet *La Operina* (published circa 1524), Ludovico degli Arrighi proposed a similar pattern, where the basic shape is recognisable as a triangle. Actually, certain angularities disappear when we write, but keeping this pattern in mind can be helpful.

Carolina

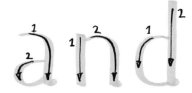

Italica

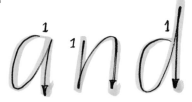

Imperial Roman letters

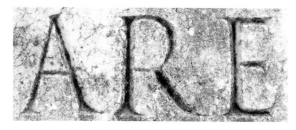

Carolingian minuscule

We owe the style of writing known today as italic script to Niccolò Niccoli, a humanist scholar who lived in Florence between 1365 and 1437. Over the course of the 15th century this style of writing came to be associated with scholars and artists devoted to the rediscovery of Greek and Latin antiquity, and soon spread throughout the main chanceries of the Italian peninsula – indeed, in calligraphy manuals it's known as cancelleresca, or "chancery cursive".

Niccoli belonged to a literary circle led by Coluccio Salutati, chancellor of Florence from 1375 to 1406. Niccoli and his fellow learned men, who studied and copied ancient manuscripts, attached great importance to the shape of letters and believed the capitals and lowercase letters of Carolingian minuscule (so called because it dated back to Charlemagne's time) to be the most legible. The former resemble our printed capitals, the second our lowercase letters.

Niccoli's invention – shared by his friend Poggio Bracciolini (1380–1459) – was that of using swift, thin strokes to connect the round, open letters of the Carolingian minuscule, while at the same time lending them a more condensed form, slanted slightly to the right. The capital and lowercase forms of this humanist script were improved by Paduan Bartolomeo Savito (1433–1511), author of some of the most beautiful illuminated manuscripts of the Renaissance. His style subscribes to the antiquarian taste for Roman monuments and inscriptions that had begun spreading through Padua halfway through the century.

handwriting and typography

Italic script

and

Cursive type

and

In the last few decades of the 15th century, movable type printing was becoming popular in Italy, as well. But unlike in Germany, where its inventor, Johannes Gutenberg, had printed his Bible in Gothic type in 1455, in Italy Roman type – based on the capital and lowercase letters so dear to the humanists – was also catching on.

In the early 1600s, punchcutter Francesco Griffo – on behalf of humanist, publisher and printer Aldus Manutius – created the first cursive type imitating the forms of italic script. There is, however, a difference between cursive type and italic cursive. When we write letters by hand, we join them together without, necessarily, slanting them. Conversely, cursive type – unlike Roman type, made up of straight block letters – features generally unconnected letters, more flowing and always tilted slightly to the right.

Nicolas Jenson's Roman type printed in 1471

us. Hæc quippe ptinus ut erit parens factus
futuri oratoris impendat. Ante omnia ne sit
quas si fieri posset sapiétes Chrysippus opta-
ret optimas eligi uoluit. Et morum quidem
io é. Recte tamen etiã loquantur: has primũ
effingere imitádo conabitur. Et natura tena-
idibus annis percipimus: ut sapor quo noua

Francesco Griffo's cursive type for Aldus Manutius

T alia quærentes (sibi enim fore cætera curæ)
R ex superum trepidare uetat · sobolem'q; priori
D issimilem populo promittit origine mira ·
I am'q; erat in totas sparsurus fulmina terras ·
S ed timuit · ne forte sacer tot ab ignibus æther
C onciperet flammas · totus'q; ardesceret axis ·
E sse quoq; in fatis reminiscitur affore tempus :
Q uo mare, quo tellus, correpta'q; regia cæli
A rdeat · et mundi moles operosa laboret ·

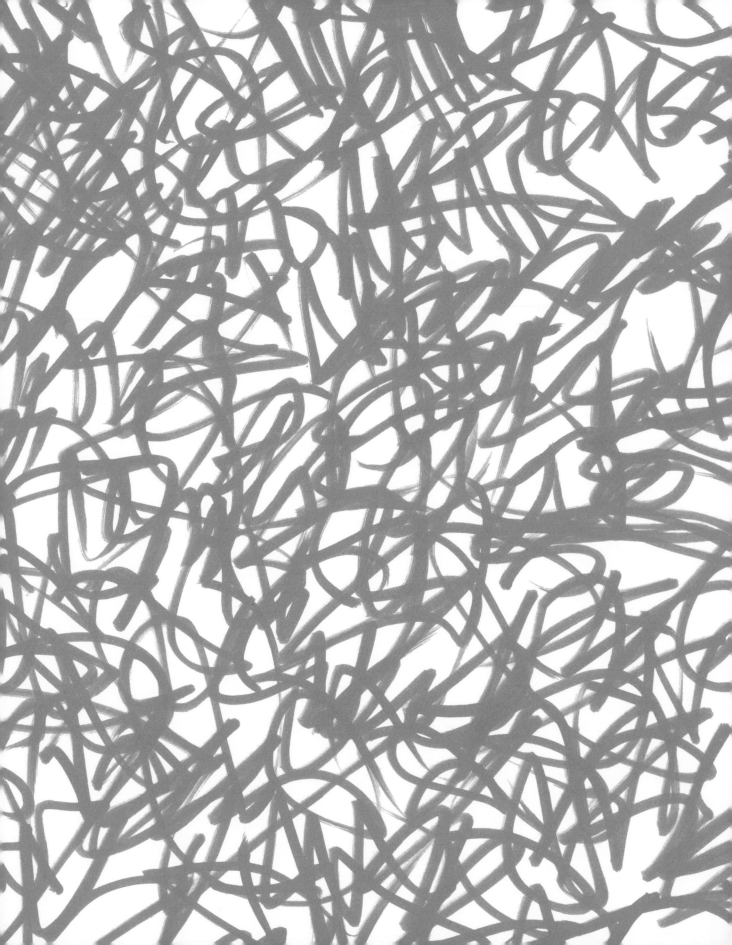

PART ONE

the basics

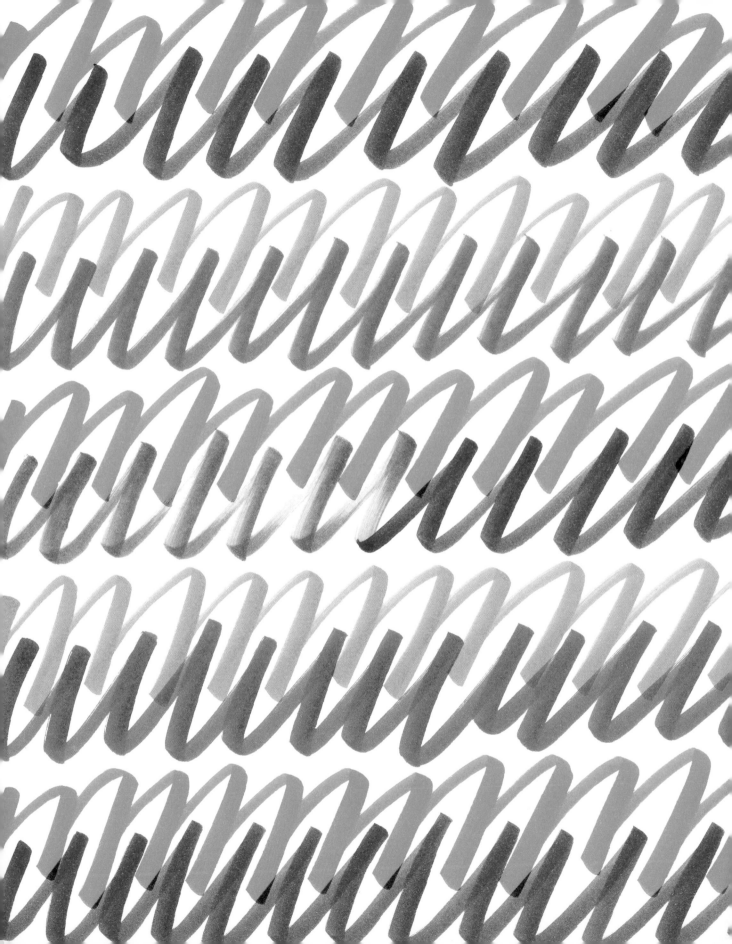

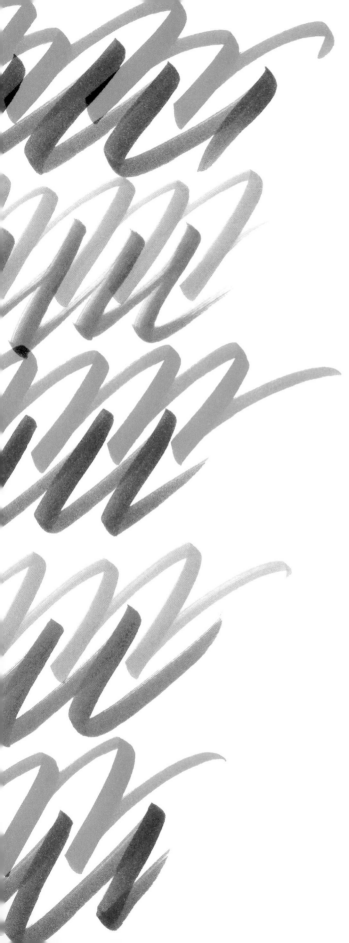

WARM-UP RHYTHMS

Our first exercises embody the spirit of the whole book.

They warm up our hearts as well as our hands. Indeed, they help us come slowly into contact with an important feature of handwriting: rhythm. In cursive writing, each sign is a gesture of the hand and body, and so everything is executed with rhythm — even when we are unaware of it.

Copy these rhythms following the directions pointed to by the arrows.
The descending stroke is thicker, the ascending stroke is thinner.

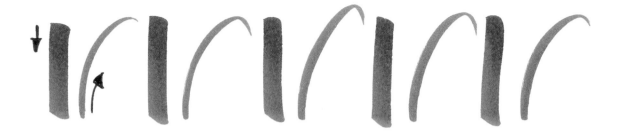

A flowing gesture matters more than graphic accuracy: try and feel the rhythm.

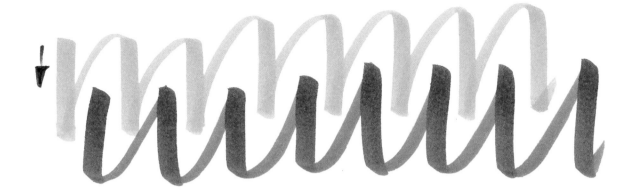

Write chains with the letter O like these without lifting your pen from the paper and maintaining constant pressure on your instrument.

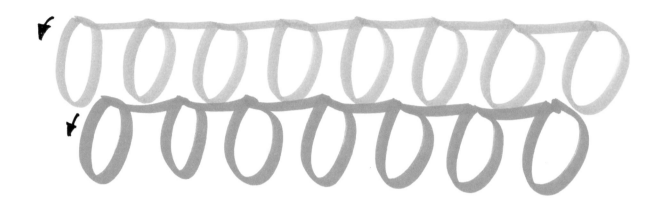

While writing the letter *n* several times — without lifting your pen — concentrate on the pressure: try writing one line applying a lot of pressure and another line applying much less.

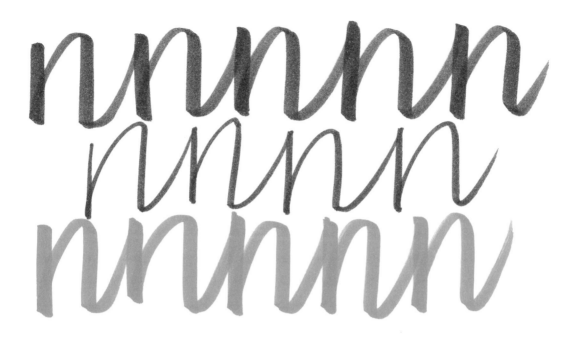

Write the letter m several times by applying more pressure on the descending stroke and less on the ascending stroke.

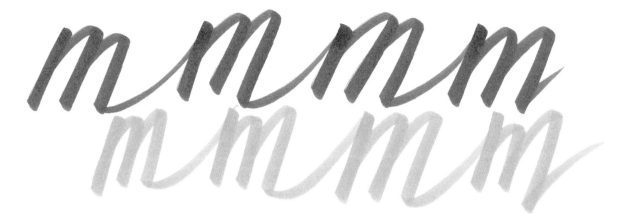

Alternate rhythms and lines of individual letters, change colours, thickness, and even pens. In slanted writing, movements are natural and swift.

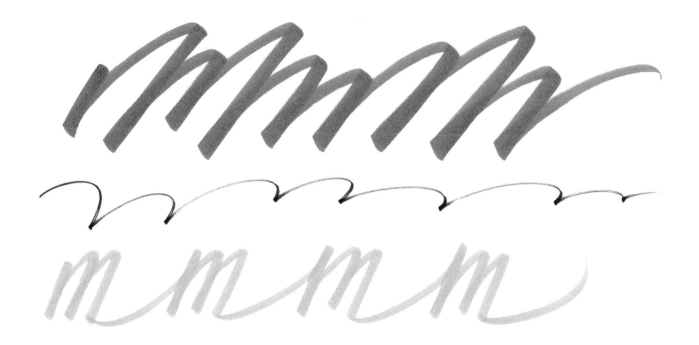

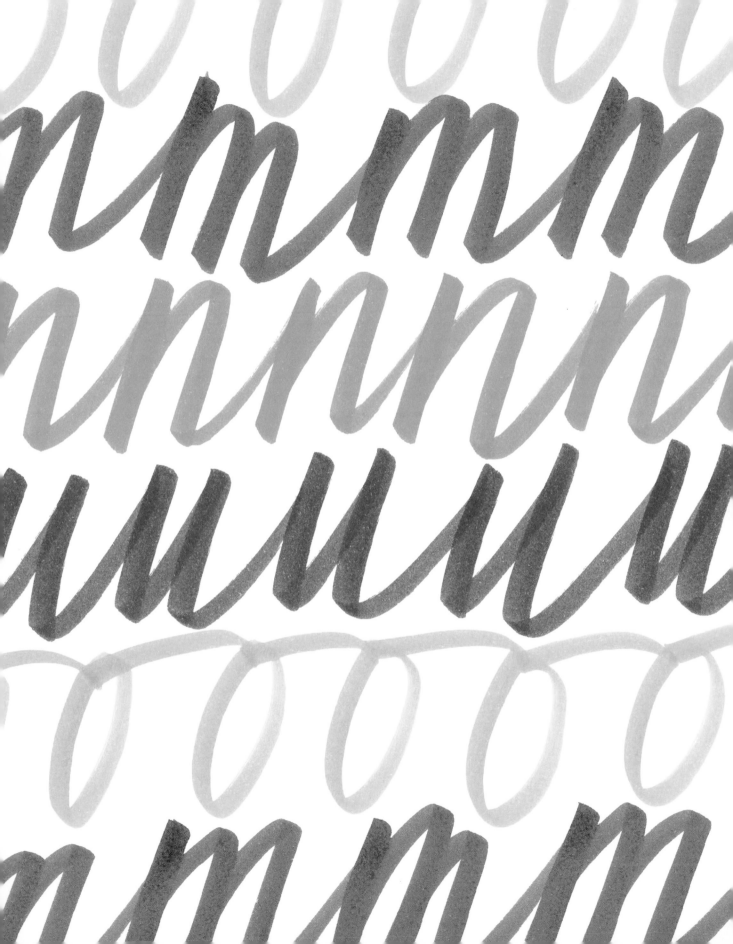

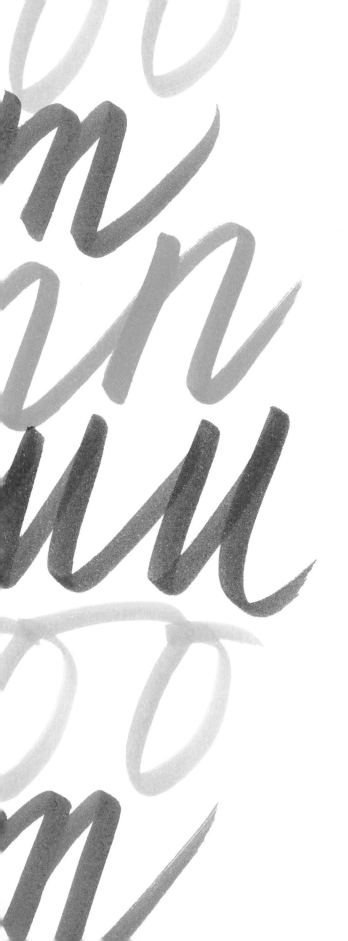

2

STROKES, SHAPES AND JOINS

Now that we've tackled the warm-up rhythms, we can focus on the shapes of letters and the way they are joined together in cursive script.

In italic script, we usually start writing top to bottom. For convenience, I often use an arrow to point to the direction of the strokes. Barring very few exceptions, the italic letterforms are written with a single stroke, so all we need to know is where to start from.

Once we've memorised the ductus of all the letters, we can introduce the *joins* and start writing them joined together – that is, in cursive.

Follow the rhythm with your hand, then write the letters over it.
A rhythm with several arch-forms represents the basic structure of the letters
m n h k b p r. I've added i j l for convenience.

Play with these sequences to familiarise yourself with the italic letters.

mmmm

bpnijh

 rhythm

Follow the rhythm with your hand, then write the letters over it.

A rhythm with several wave-forms represents the basic structure of the letters a d g q c as well as f and e. The initial movement (pointed to by the arrow) is counterclockwise. We can add the letters u y t for which this rhythm is similarly congenial.

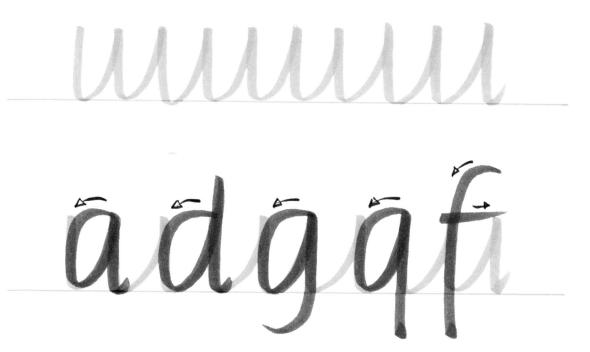

Pay attention to how your body feels as you repeat the movements.

a e t u u y

ISI OLLLLLLL

S O

Although these letters don't have shapes similar to those in the u and n rhythms, they share the same width.

M M MM X Z I

V W X Z

Copy these words following the direction of the arrows.

These words are written in cursive, the letters are joined together by different coloured strokes called joins or ligatures.

minimum

minimum

minimum

Do you notice how a join takes up the same space as the width of a letter?
That space is the breadth of writing, it is the rhythm.

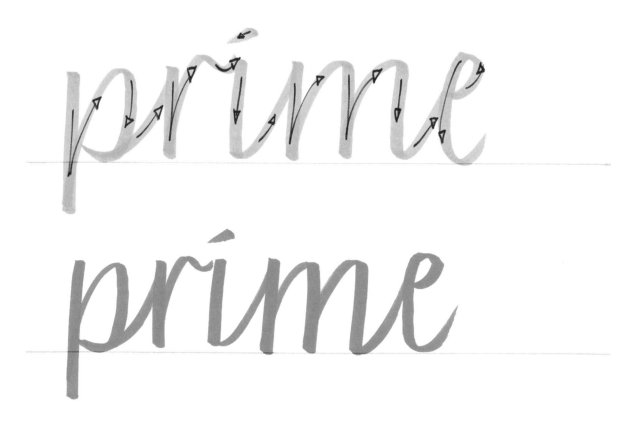

Cursive

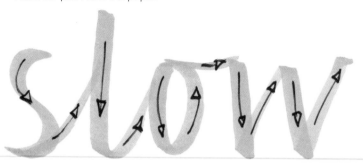

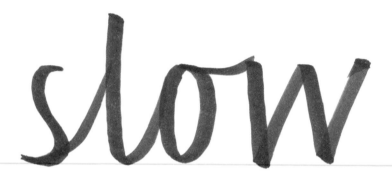

The pen is usually lifted at the end of a join. In the word *age*, the dots indicate where the pen moves in the air.

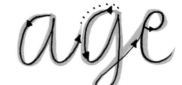

gentle

gentle

joins

ofvwxz

adgqagi

csetuycs

mnhkm

bprijlbp

rhythm

npnpnpn

nrnrnrnr

nhnhnhn

nknknknkn

nbnbnbn

ninjni

nanana

ndndndn

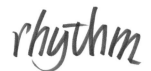

Write some rhythms alternating the letter n with another letter of the alphabet. If you lose the rhythm, go back to writing lots of n or lots of u — that is, the basic rhythms we learned at the beginning of this section.

ncncncncnc

nsnsnsnsn

ngngngn

ntnyntny

rhythm

nononon

nfnenfne

nvnvnvnvm

nwnwnwnwn

nznznznzn

Cursive

the quick brown fox jumps over the lazy dog

Unlike the previous exercises, here you have to join letters of actual words without losing the rhythm or neglecting the shapes. You'll need a lot of practice in order to do so. If necessary, repeat the basic rhythms and the ones alternating the letter n with other letters, especially the ones you had the most trouble with.

the quick
brown fox
jumps
over the
lazy dog

Copy the pangram, line by line.

the quick

brown fox

jumps

over the

lazy dog

variations

aba aba

afa afa

ara ara

aza aza

Some letters present multiple forms. Below I've written a few combinations using the most common forms. These variations can enrich our writing. Conversely, with the letter t we can vary the join: it can be both diagonal and horizontal.

asa **asa**

ala **ala**

ata **ata**

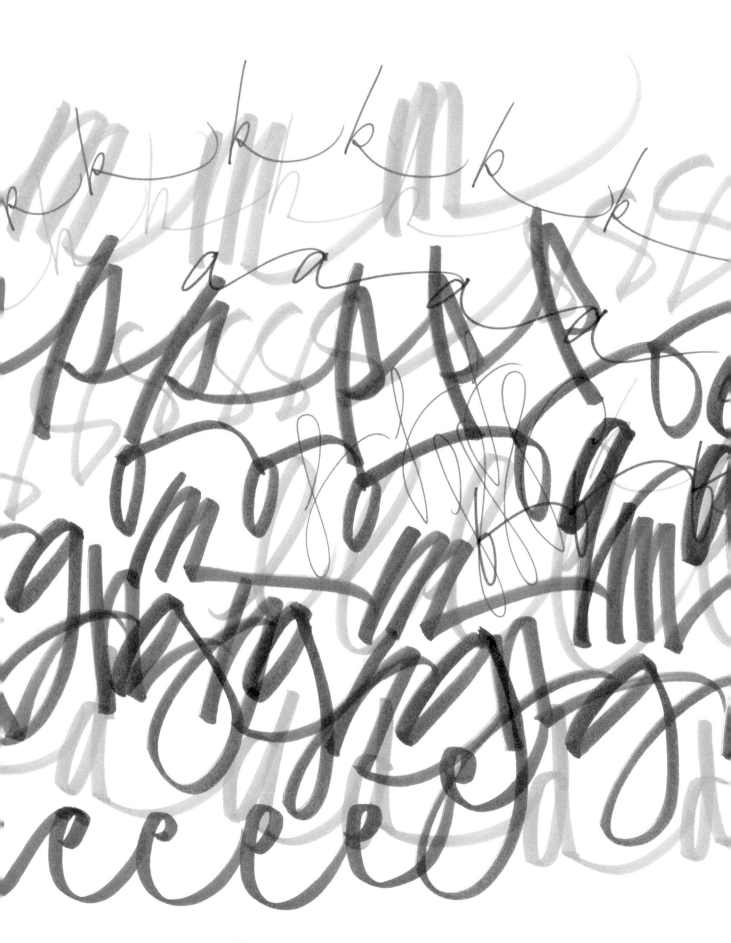

VARIATIONS
IN RHYTHM

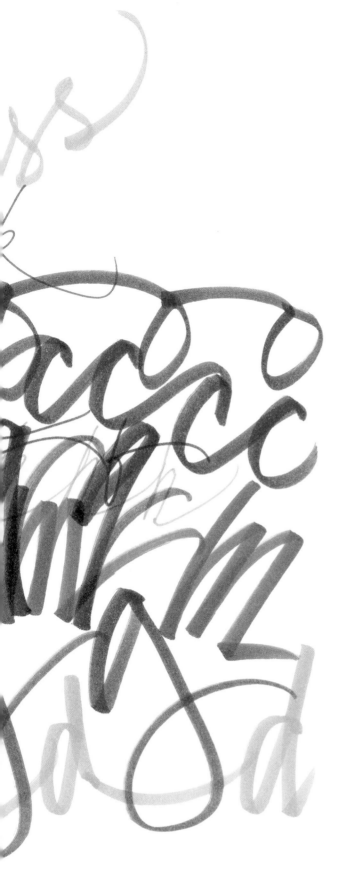

We've seen that the letters of italic script (except the letter e, which starts mid-air) begin from the top, following a specific ductus. We've also seen how they can become cursive by means of joins.

Now we'll learn how to modify everything – letters and joins – to obtain *variations in rhythm* for our cursive writing.

rhythm

mountain

mountain

Copy this word with alternating rhythm.
Here the letters are slightly narrower than the ligatures.

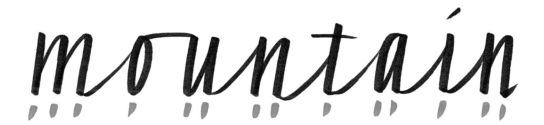

Write the same word in smaller size with a pointed pen,
slowly at first

mountain

and then faster.

mountain

Would you tell me, please

which way I ought to go

from here?

I don't much care where,

said Alice. Then it doesn't

matter which way you go,

said the cat.

How does it feel to write with a smaller pen?
You can begin with slow strokes.

That depends a good deal
on where you want
to get to, said the cat.

Trace and then copy this word.

Notice how the vertical strokes are thicker and how the joins are broader than the letters.

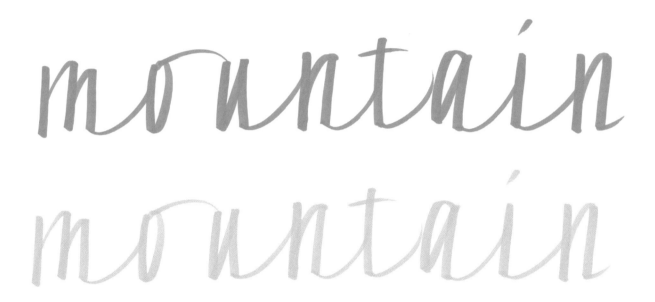

The thicker joins emphasise a horizontal rhythm.

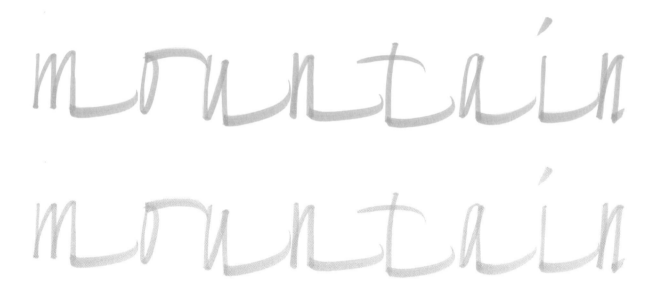

mountain

mountain

mountain

mountain

Rewrite the letters of this word with axes slanted left and right.

Repeat the exercise with any word.

Copy this sentence with unjoined letters. Follow the arrows if you're unsure of the direction of the strokes.

Notice how there isn't much space between the words and how the shapes are wedged together so as to strengthen the overall composition.

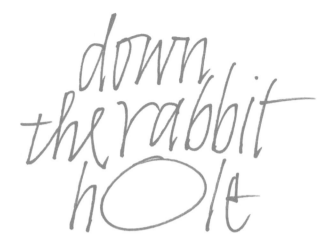

down
the rabbit
hole

down
the rabbit
hole

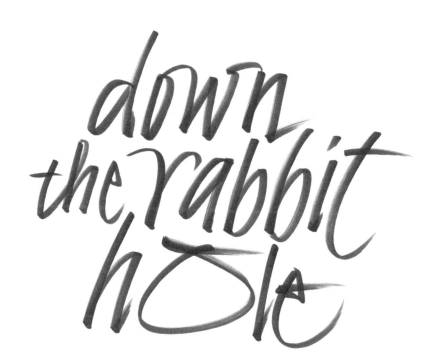

down
the rabbit
hole

WHO ARE YO

'SAID THE CATE

'THIS WASN

ENCOURAGIN

OPENING F

CONVERSATI

ALICE REPLIED,

SHYLY I HARDLY

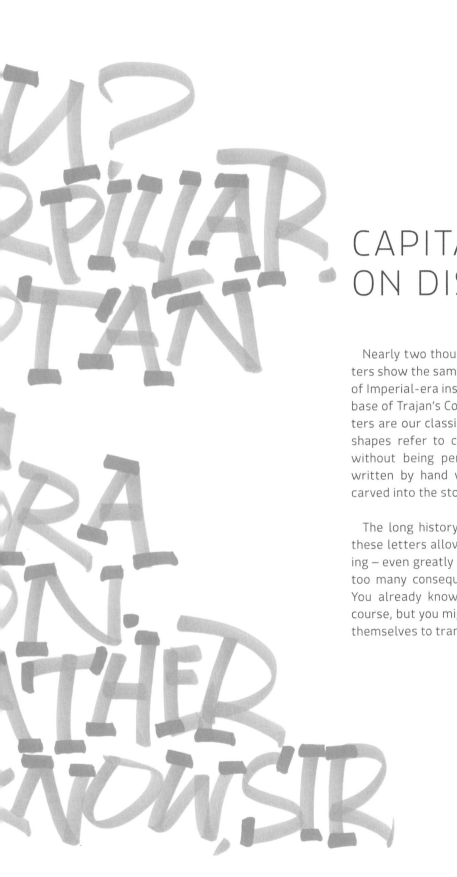

CAPITAL LETTERS
ON DISPLAY

Nearly two thousand years later, our capital letters show the same structure of the Roman letters of Imperial-era inscriptions, such as the ones at the base of Trajan's Column in Rome. Those capital letters are our classical models par excellence. Their shapes refer to circles, rectangles and triangles without being perfectly geometrical. They were written by hand with a paintbrush before being carved into the stone.

The long history and extreme recognisability of these letters allows us to personalise them, altering – even greatly – their canonical shapes without too many consequences as far as legibility goes. You already know them and can write them, of course, but you might not know how well they lend themselves to transformation!

Practice writing thick strokes in different directions by holding your pen sideways. You can create a great variety of marks with a brush point tip.

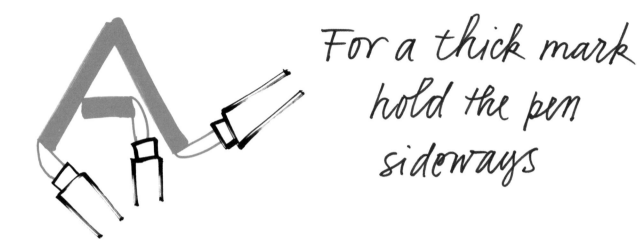

For a thick mark hold the pen sideways

Have fun discovering how many other types of strokes you can obtain by using a brush point pen.

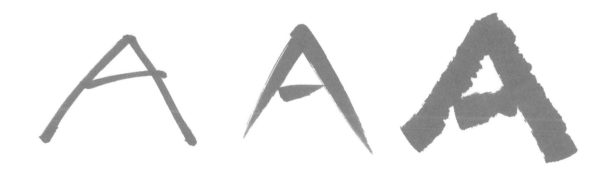

You know the capital letter forms, feel free to interpret these shapes.

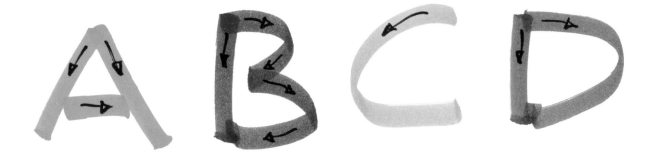

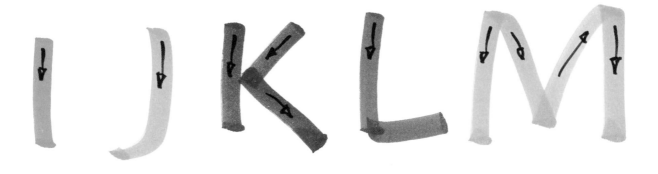

N O P Q

R S T U V

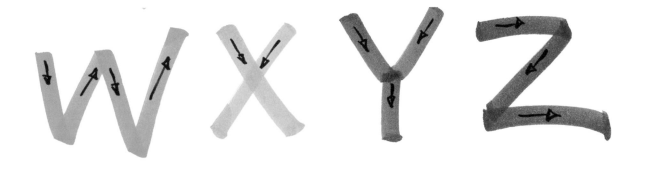

ALICE AND THE CAT

The first three clusters of marks are made with single repetitive gestures. The fourth is the application of the same concept, using letters. Copy them, then try your own clusters.

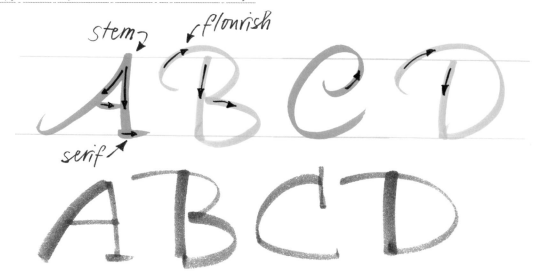

stem
flourish
serif

A B C D

A B C D

E F G H

E F G H

Ornaments can be added without losing the legibility of forms.

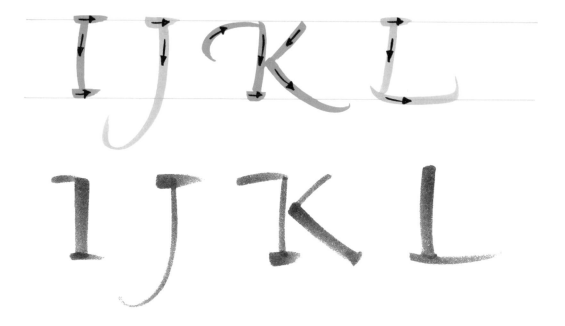

M N O P

M N O P

Q R S T

Q R S T

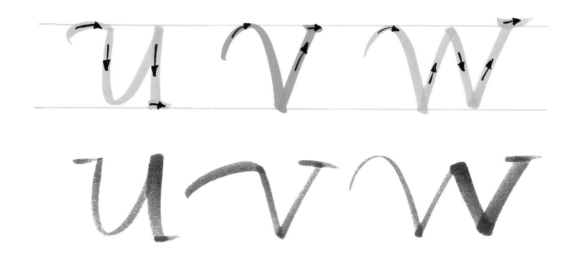

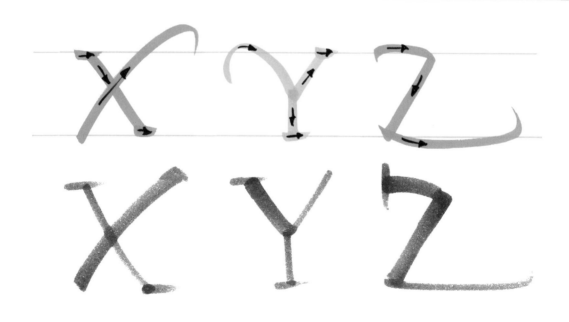

Red Orange Green Blue

Write other words of your choice that start with capital letters.

Red

Blue

Orange

Green

Yellow

Copy these words written in different ways.
Then try and invent other combinations.

Thick and thin capital letters

OCEAN

Narrow and thin capital letters

Narrow, thick and thin capital letters

OCEAN

Thick, narrow and
broad capital letters

Thick and thin, narrow and
broad capital letters, with
the axis slanted to the left
and the right

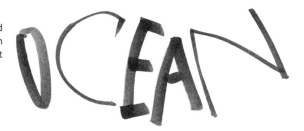

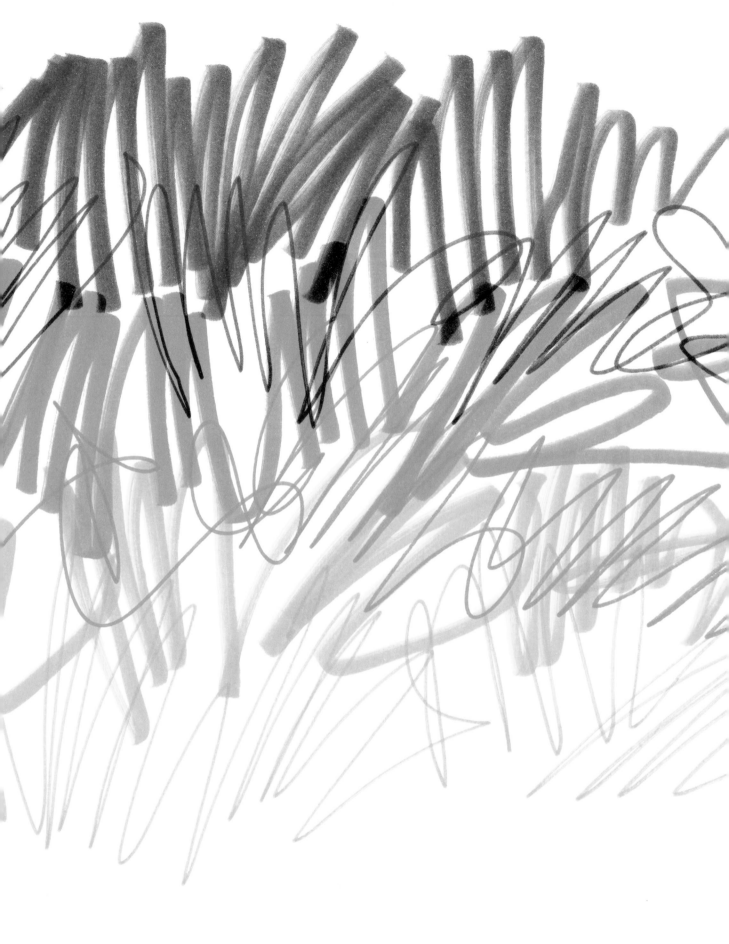

PART TWO

freehand

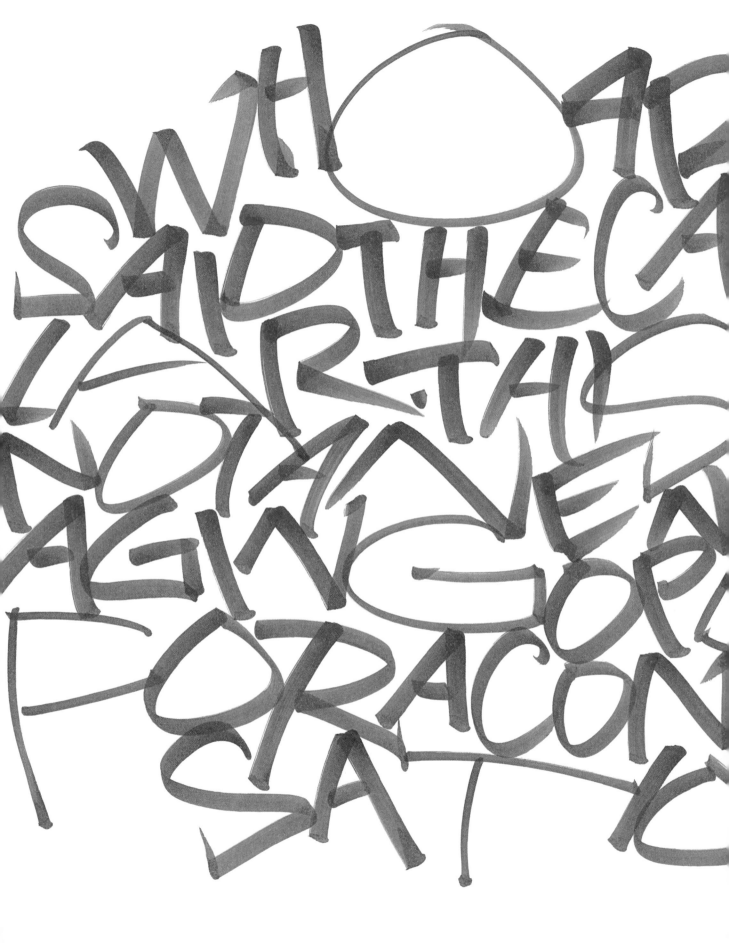

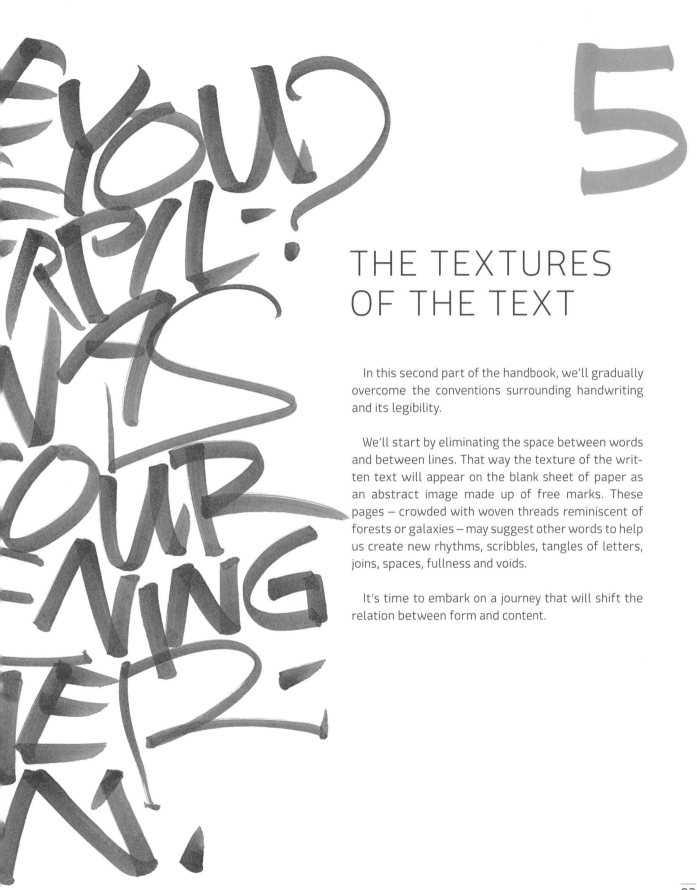

THE TEXTURES
OF THE TEXT

In this second part of the handbook, we'll gradually overcome the conventions surrounding handwriting and its legibility.

We'll start by eliminating the space between words and between lines. That way the texture of the written text will appear on the blank sheet of paper as an abstract image made up of free marks. These pages – crowded with woven threads reminiscent of forests or galaxies – may suggest other words to help us create new rhythms, scribbles, tangles of letters, joins, spaces, fullness and voids.

It's time to embark on a journey that will shift the relation between form and content.

Texture

Copy these words however you like, but make sure the letters touch each other, creating a texture of fullness and void.

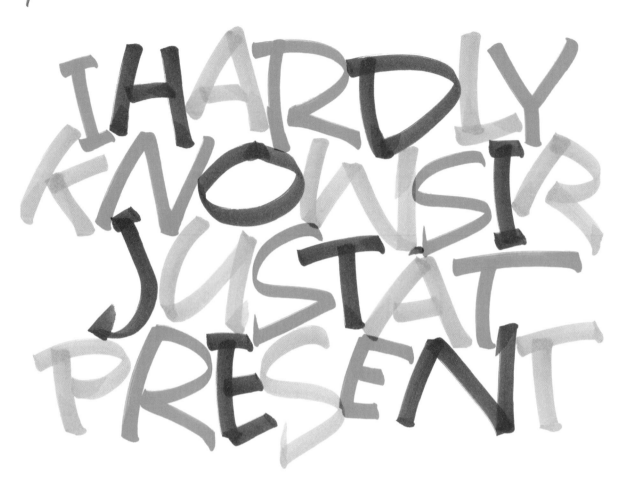

I HARDLY KNOW SIR JUST AT PRESENT

Notice how I varied the width of the E and the W in the sentence below.

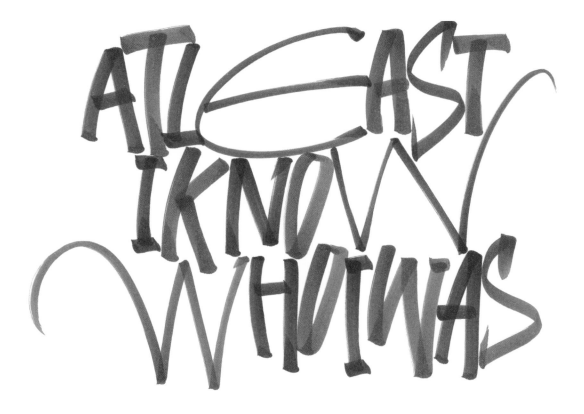

Texture

Thus far, we have looked at letter space and inter-line space with regard to legibility in texts. In this piece, I am weaving words without space and lines to emphasise the visual impact of the composition.

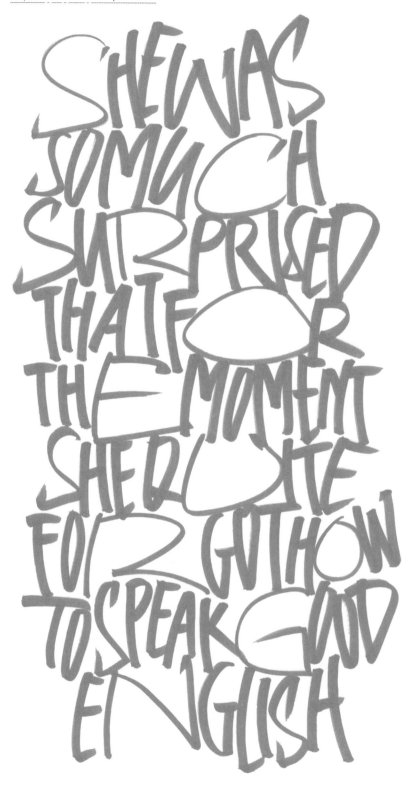

Trace the text reproduced in grey with a colour of your choice.

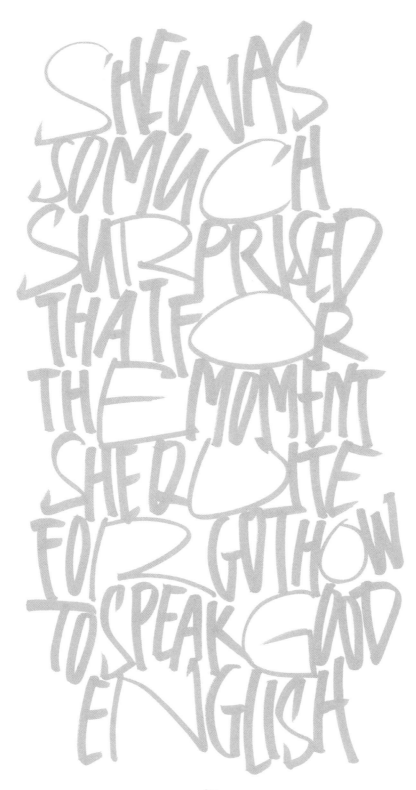

Would you tell me, please, which way I ought to go from here? That depends a good deal on where you want to get to said the cat. I don't much care where—said Alice.

Trace the texture in grey, paying attention to the colour combination.

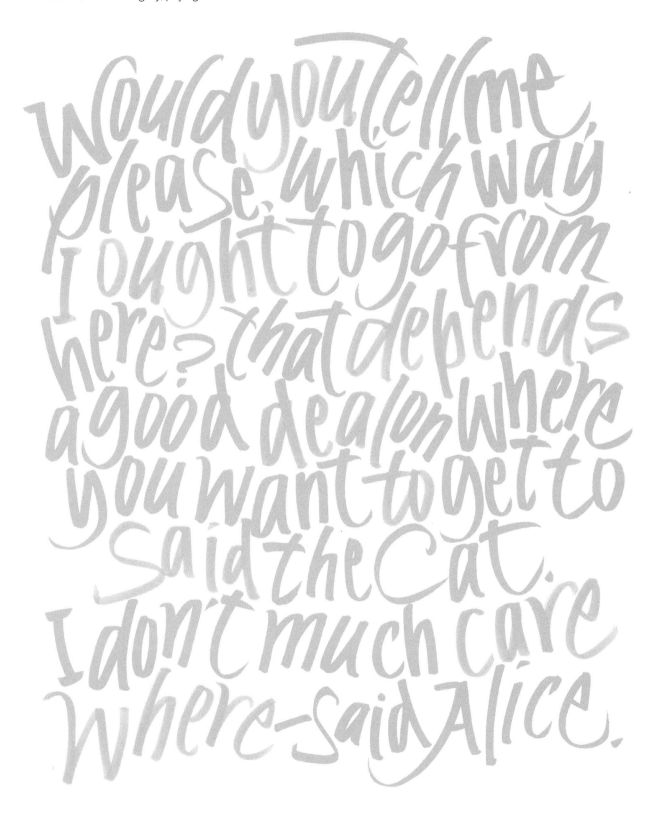

Would you tell me, please, which way I ought to go from here? That depends a good deal on where you want to get to said the Cat. I don't much care where – said Alice.

Texture

Keep playing with the shapes and spaces of the letters to emphasise visual compositions.

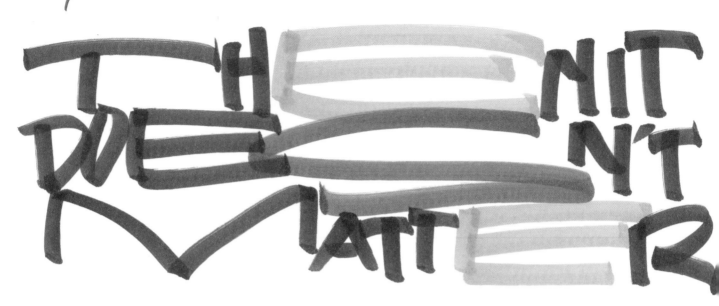

For example, write words with broad joins between letters.

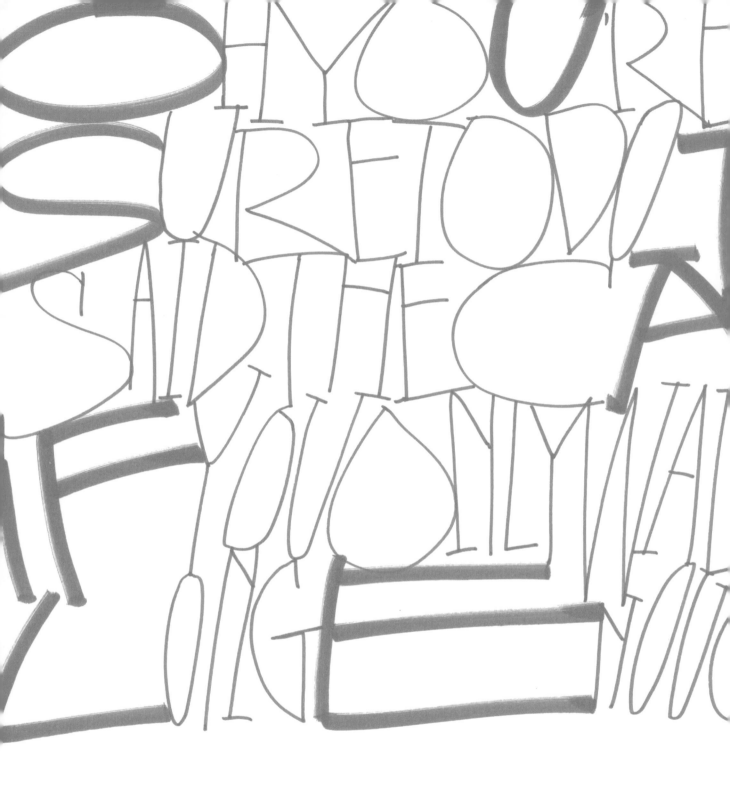

Complete the texture by adding new words and maintaining the same tension between spaces and forms. If you want, you can change colour.

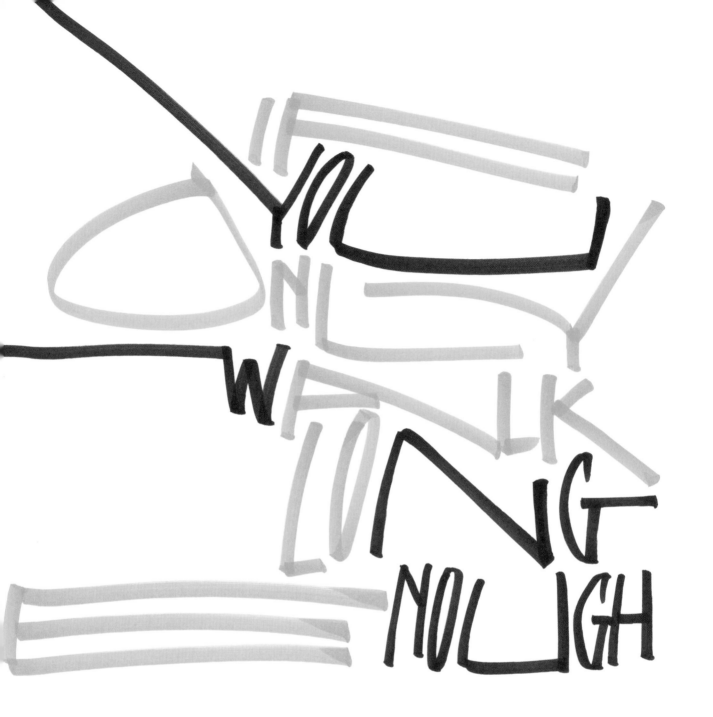

IF YOU ONLY WALK LONG ENOUGH

Complete the texture by adding new words. Maintain the same tension between spaces and forms as shown in the example.

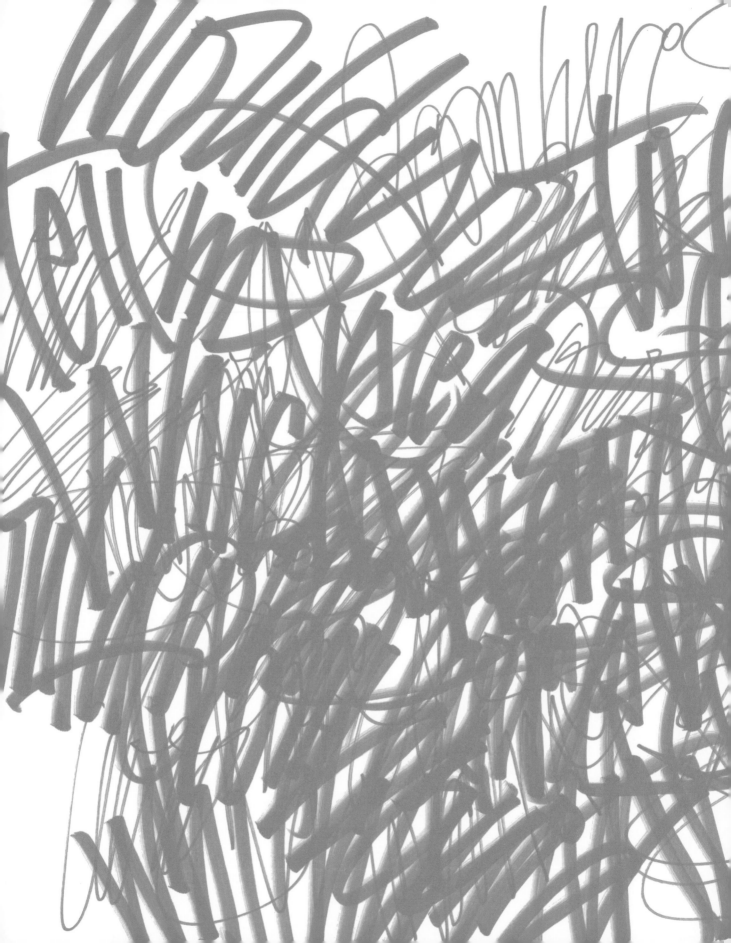

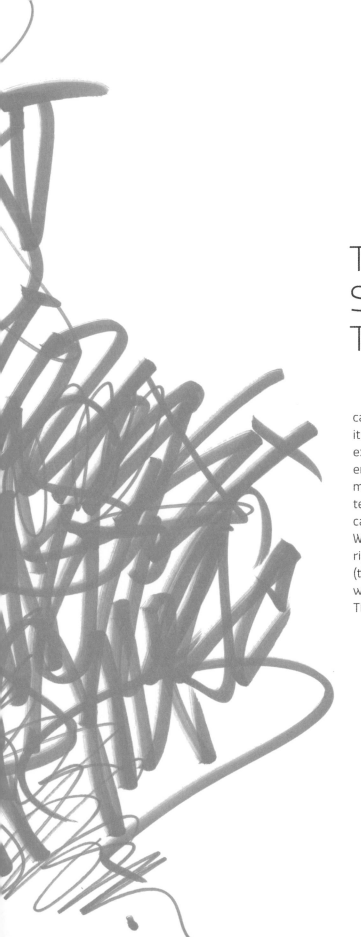

6

THE EXPRES-SIVENESS OF THE MARK

What, exactly, is an expressive mark? It's a sign that can express thoughts, feelings, emotions. The mark itself takes on the ability to communicate. Just like an expressive face or gesture can sometimes convey an emotion more effectively than a word, so too can the mark. To free its expressive force, we can write letters that range from very small to very large sizes. We can write with our dominant or non-dominant hand. We can write from top to bottom or vice versa, from right to left or from left to right or boustrophedon (that is, both at the same time but alternating them, with every other line of writing flipped or reversed). The results are always unexpected.

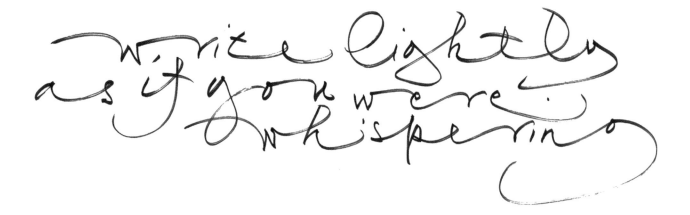

write lightly
as if you were
whispering

happy

decisive

timid

Write with your non-dominant hand and fill this page with capital and lowercase forms of letters of your choice. Unsteady and irregular strokes are also beautiful.

ILLEGIBLE HANDWRITING

Writing exists and has evolved for communication purposes. Legibility has always been seen as its main function, but we know that it's not the only one: it can have an expressive function, as we learned in the previous section, or even a merely visual one (that is, released from any need for legibility), as we are about to discover.

We've seen how we can detect the connection between rhythm, breathing, and heartbeat while writing. In other words, when we write, we're not only using our hand, but our whole body. And illegible handwriting helps us focus more on our personal experience. You can familiarise yourself with this feeling by completing lots of exercises with your eyes closed and without worrying about legibility or the graphic result.

A deliberately illegible handwriting – even with my eyes open – allows me to change shapes or to disregard spaces. This type of writing offers the pure pleasure of playing between form and space, in addition to the balance between fullness and void.

I think writing can turn into a dance when we sense the space and approach it as a lover.

Think of a short sentence that you like and can keep in mind easily. Write it however and wherever you want on the paper. There's only one rule: never lift your marker, not even between words or lines, like in this example. Complete this exercise with your eyes closed.

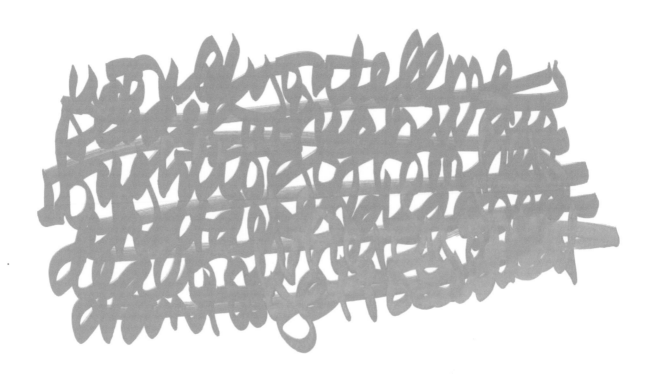

Though we aren't able to concentrate on shapes and their legibility if we write with our eyes closed, we instantly become aware of the close connection between gesture, rhythm, breath and heart.

Holding a pen in each hand, write from top to bottom,
starting from the centre of the paper and with your eyes closed.

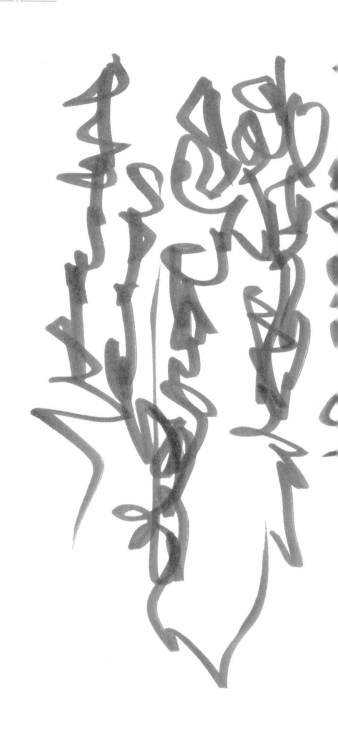

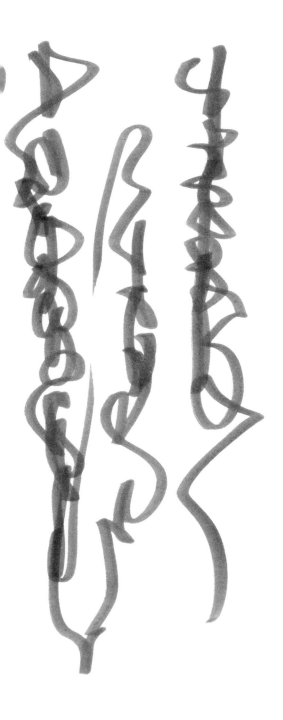

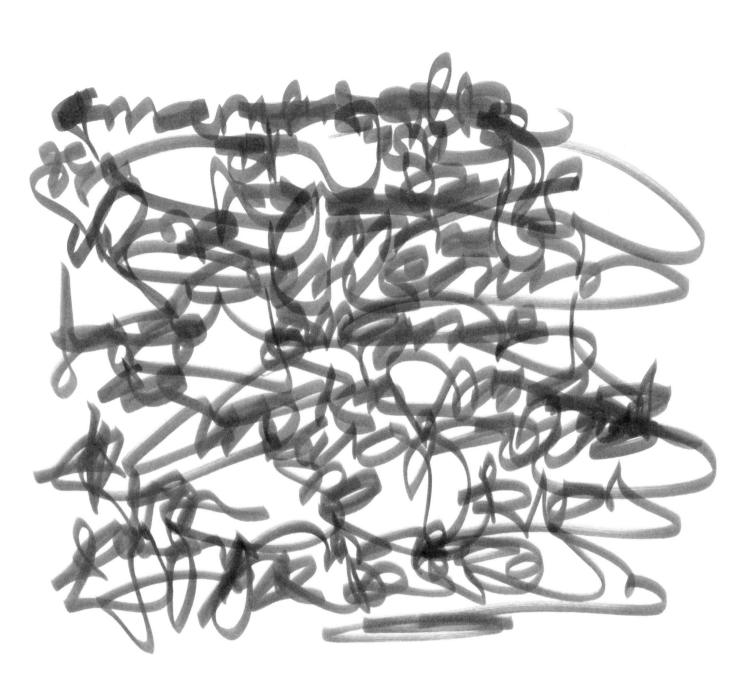

Write your own illegible text.

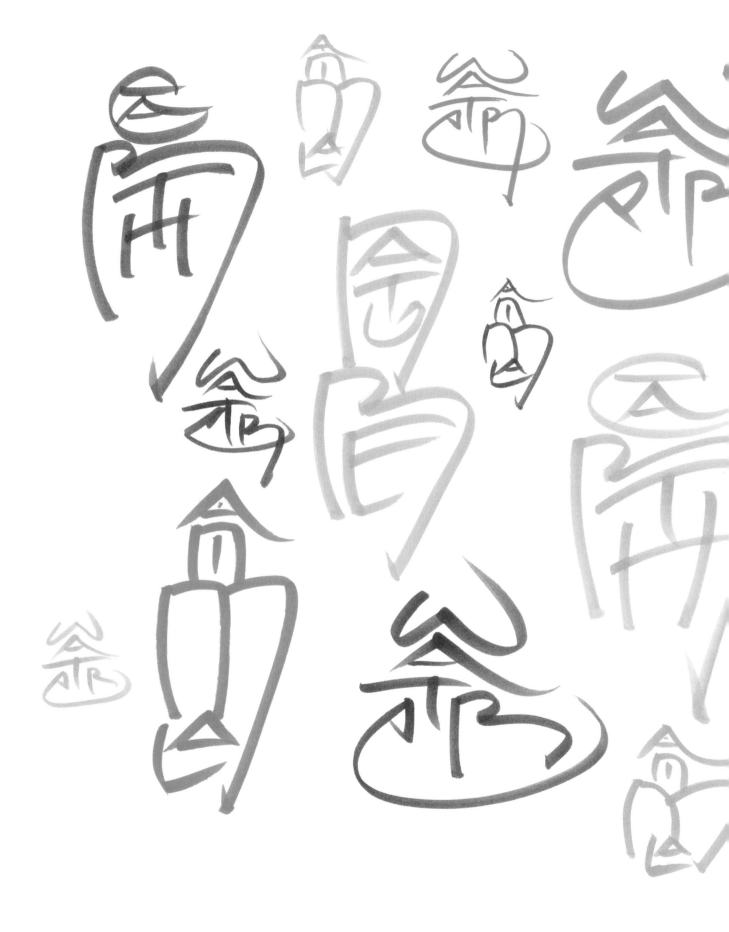

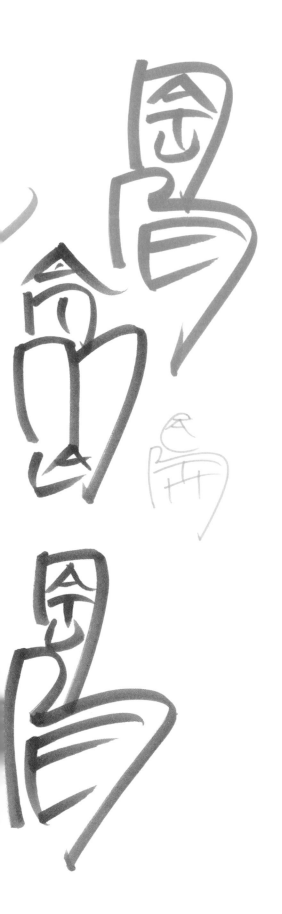

INTERCULTURAL CALLIGRAPHY

Handwriting meant not as a container of content, but as an expression of our values and emotions can provide an interesting key to other cultures.

My first attempt to create works influenced by Chinese and Japanese calligraphies was inspired by the Chinese artist Xu Bing's project Square Word Calligraphy. Like him, I developed a writing style organising Latin letters in visual appreciation of Chinese characters, or rather, logograms.

While doing this, I felt the gap between writing and drawing diminishing. The exercise provided so many opportunities to play with shapes and to make the words have life. It put some distance between the idea that the shapes of writing are at the service of content. I also realised how little I know of the history of the great developments that established the features and nuances of Chinese and Japanese calligraphies. Thus, non-alphabetical writing systems can provide opportunities to question and deepen our own idea of writing.

The exercises we are about to tackle are linked to this specific field of research, which I've called intercultural calligraphy.

Trace and then copy the logo E A R T H.

Notice how the letters E A and R T H in this logogram are nestled into each other. Notice also that R T H have tilted horizontal strokes but they appear in balance because of the last longer stroke in R. This balance is not perfect or static but dynamic, like a moving figure.

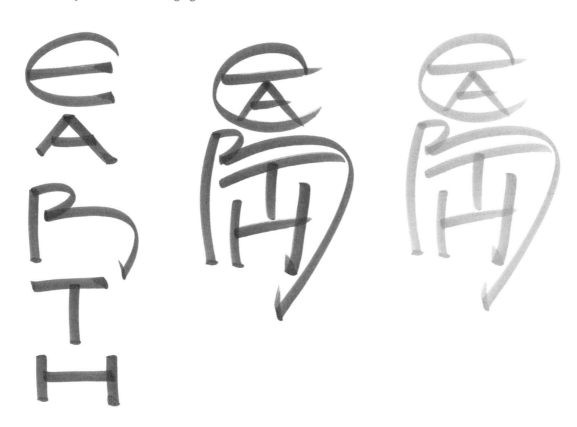

Write the logo for your name. Keep trying until the result satisfies you.

The direction of writing and reading is top to bottom, and all the letters follow the classic ductus, although they can be condensed or taut like a spring.

Copy the WATER logo two or three times, then reinvent it.

The letters vary in size and length for each stroke to balance the composition and, whenever possible, they are nestled into each other.

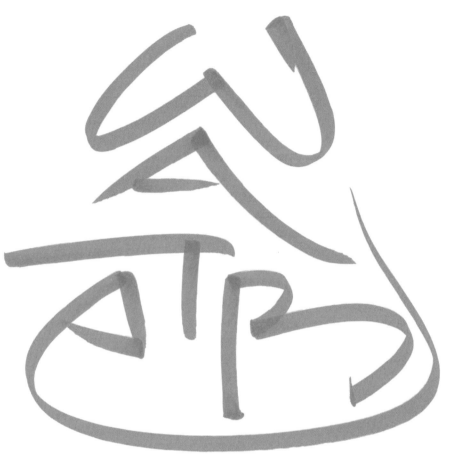

Happy Exploration of the Blank Pages

EPILOGUE

Writing by hand based on the guidelines contained in this handbook may have been confusing — especially in the beginning, when you had to develop the rhythms and shapes of italic cursive, so different from the handwriting most of us learned in school. Once we took possession of its rhythm and ductus, however, we didn't just play with its serifs and flourishes, etc. No, we operated on the structure underlying the convention linking word to mark: the organisation of the space between letters, words and lines. We overcame the conventions of legibility, suddenly finding ourselves faced with a scenery devoid of points of reference: a blank sheet of paper and all its free space.

Sometimes my desire to communicate is not commensurate with my ability to put into words what I wish to convey. In writing by hand, I write gestures, silences, and myself. There is an honesty and a directness of emotions that handwriting allows me to say more than the words in my possession.

This book comes out of my experience working with writing and teaching calligraphy. I hope it communicates to you how writing by hand can transform a blank sheet of paper into a dynamic playground for spaces and lines.

Happy writing.

Monica Dengo

Further reading

Readers interested in investigating aspects of writing by hand merely touched on here can refer to the following list of books that are especially dear to me. Some titles are only available in their original language.

Giorgio Raimondo Cardona
Antropologia della scrittura
Loescher, 1981

A. Khatibi, M. Sijelmassi
The Splendor of Islamic Calligraphy
Thames and Hudson, 1995

Kazuaki Tanahashi
Brush Mind
Parallax Press, 1998

Scritture. Le forme della comunicazione
Edited by Giovanni Lussu, Antonio Perri, Daniele Turchi
Aiap, 1998

L'aventure des écritures. La Page
Bibliothéque nationale de France, 1999

Roland Barthes
Variations sur l'écriture
Editions du Seuil, 1994

Hans Joachim Burgert
The Calligraphic Line: Thoughts on the Art of Writing
Burgert-Handpresse, 2002

Daniel Stern
The Present Moment in Psychotherapy and Everyday Life
WW Norton & Co, 2004

Jerome Silbergeld, Dora C. Y. Ching, Xu Bing
Persistence - Transformation: Text as Image in the Art of Xu Bing
Princeton University Press, 2006

Ouyang Zhongshi, Wen C. Fong
Chinese Calligraphy
Yale University Press, 2008

Ernst H. Gombrich
The Sense of Order
A Study in the Psychology of Decorative Art
Phaidon Press, 1994

Ewan Clayton
The Golden Thread: The Story of Writing
Atlantic Books, 2013

www.scritturacorsiva.it

www.smed2015.it

THE MEANING OF A JOURNEY

I met Monica Dengo a few years ago, and I instantly felt a debt of gratitude towards her – as I imagine will happen to most readers of *Leave Your Mark* – for enabling me to rediscover the pleasure of writing by hand. What's more, she made me truly aware of the value of handwriting, of its importance, of the multiplicity and variety of its forms and traditions. So much that in January 2015, along with Daniela Moretto and other "pen friends" – Laura Bravar, Daniele Capo, Barbara Deimichei, Caterina Giannotti, Maria Pia Montagna, Claudio Peressin, Kit Sutherland – we founded the association SMED - Scrivere a Mano nell'Era Digitale (Writing by Hand in the Digital Age).

The events leading up to the birth of SMED and this book are worth mentioning. The story may have begun in 2007, when Monica held a handwriting course for teachers at the Convitto Nazionale of Arezzo, Italy. Or shortly thereafter, in 2008, when a short calligraphy course for elementary-school children marked the start of her collaboration with the Istituto comprensivo of Terranuova Bracciolini, the municipality in the province of Arezzo where Poggio Bracciolini was born.

This experience led Monica, in collaboration with the principal and some of the teachers, to start a

Afterword by Massimo Gonzato

specific pilot project on teaching handwriting to the first three years of elementary school. In 2012, the pupils involved completed third grade "with more than satisfactory results". Right afterwards, the project – which by then had a name: *Scrittura Corsiva* (Cursive Writing) – became a website first and a book later (2013), eventually resulting in a training course for instructors at the LabCom of the Ca' Foscari University in Venice (2014). The idea of founding an association to promote the knowledge and practice of writing by hand took shape at that time with the people who, in various measures and capacities, took part in the process.

By this point, Scrittura Corsiva is ready to be taken into schools (it even includes a typeface for composing texts in italic script). SMED, which has been just founded, takes the project upon itself to put it into practice. We need members willing to volunteer at fairs, festivals and other public events, as well as members willing to teach and able to train other instructors. Website and book aren't enough: the association needs its own website, and programmes, pamphlets, alphabet books, exercise books, etc., are also needed. This is precisely what SMED has set out to do up till now.

What is then, exactly, Scrittura Corsiva? An educational offer that stands out for its artistic-playful approach, knowledge of the italic handwriting model, the gradual introduction of alphabetical forms and the utmost attention paid to motor and graphic activity. We could jokingly describe it as a prequel to *Leave Your Mark* – or as its kids' version. The two offers are aimed at different users/readers who, however, share the same goals: to contribute to the individual and collective rediscovery of the pleasure of writing by hand, and to safeguard access to this expressive skill. This is why *Leave Your Mark* represents a new and powerful tool for SMED to continue along the path it has taken.

Leave Your Mark

was designed, written and illustrated by Monica Dengo

PAGE LAYOUT AND TEXTS EDITED BY

Daniela Moretto, Massimo Gonzato and Tsering Wangmo Dhompa

TRANSLATION

Contextus srl – Pavia (Daniela Innocenti)

TYPOGRAPHY

Macho, font designed by Luciano Perondi and produced by Cast, Cooperativa anonima servizi tipografici, Bolzano.

Italica, font created by Monica Dengo and Riccardo Olocco in collaboration with Daniele Capo and funded by the Istituto comprensivo Giovanni XXIII of Terranuova Bracciolini.

CREDITS AND ACKNOWLEDGEMENTS

Thanks to: the Museo Correr Library of Venice for the image related to Carolingian minuscule published on p. 12; the Civic Library of Verona for the images on p. 13.

The photo with capital Roman letters carved on stone on p. 12 belongs to the author.

The sentences and words written on pp. 56–57, 64–65, 66–67, 68–69, 76–77, 79, 92–93, 94–95, 96–97, 98–99, 100–101, 102–103, 104–105, 106–107 are from *Alice's Adventures in Wonderland* by Lewis Carroll.

The Deutsche Nationalbibliothek lists this publication in the Deutsche Nationalbibliografie; detailed bibliographic data are available on the Internet at http://dnb.dnb.de

ISBN 978-3-7212-0998-3
© 2020 Niggli, imprint of Braun Publishing AG, Salenstein
www.niggli.ch

The original Italian edition was published under the title "Lascia il segno. Il piacere di scrivere a mano per sé e per gli altri".
© 2017 by Cart'armata Edizioni srl
Terre di mezzo Editore
via Calatafimi 10, Milano, Italy
terre.it

1st edition 2020